RELICS of ANTHRACITE in NORTHEASTERN PENNSYLVANIA

VOLUME II

MICHAEL G. RUSHTON

AMERICA
THROUGH TIME®
ADDING COLOR TO AMERICAN HISTORY

Thank you to my mother and father and all the members of my extended family who shared stories, ideas, and tidbits of information that went into this book.

America Through Time is an imprint of Fonthill Media LLC
www.through-time.com
office@through-time.com

Published by Arcadia Publishing by arrangement with Fonthill Media LLC
For all general information, please contact Arcadia Publishing:
Telephone: 843-853-2070
Fax: 843-853-0044
E-mail: sales@arcadiapublishing.com
For customer service and orders:
Toll-Free 1-888-313-2665

www.arcadiapublishing.com

First published 2023

ISBN 978-1-63499-467-5

Typeset in 10pt 13pt Sabon
Printed and bound in England

Contents

Acknowledgments

Lackawanna and Wyoming Valley Rail Historical Society
Huber Breaker Preservation
Ed Philbin
Ed Miller
Don Kane, Jr.
Chris Murley

Introduction

It is now 2022. At this time, none of the old-time coal breakers are left standing in the Northeast Pennsylvania. The Huber Breaker was the last breaker standing in Luzerne County. The Sullivan Trail Breaker, Harry E., and Huber have been demolished. The St. Nicholas to the south of us has been demolished too.

Culm banks and rust stained creeks and rivers are all the reminders we have of "King Coal" today. Despite the trend toward "Green Fuels," coal is still reliable energy and many homes still burn it. But wait, since coal came from plants, is it not green fuel too? Think about that for a while.

Volume II will touch on the Garment/Textile industry with a series of photos.

This Photo Illustrates the Region

This photo illustrates the hard coal region. Off in the distance there is culm pile. In the forground is St. Mary's Byzantine Church, Hazleton.

Immigrants came from overseas to mine the anthracite coal. Also to work on the railroads and in factories. They established churches to worship in their own language and rite. Schools were built to teach English and educate the children.

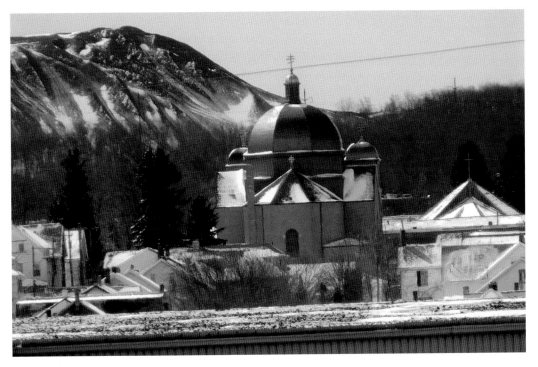

St. Mary's Byzantine Church in Hazleton, PA.

Stay Out, Stay Alive

It can be very dangerous going into abandoned coal-mining areas. There are deep shafts, steep hills (known as highwalls), and abandoned buildings and equipment. There are water hazards like deep stripping pits and creeks.

When the author did photography, he stayed on the outskirts of mine areas or followed roads or trails.

Coal Breakers and Anthracite Topics

Avondale Colliery Site/Memorial Park

Since the author visited this former colliery site when mountain biking in the mid-1990s, it has been cleaned up. Some of the old, crumbling buildings and culm and rock have been removed.

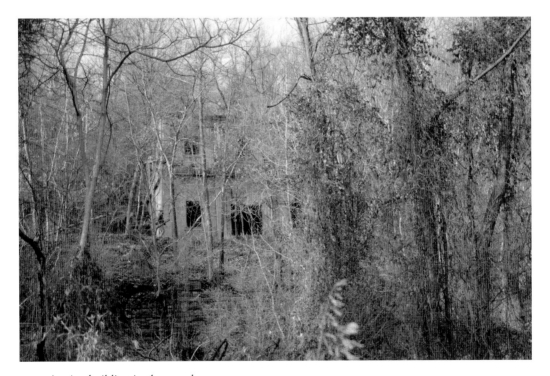

A mine building in the woods.

Ventilation was achieved by a furnace at the bottom of the shaft. Apparently, the wooden lining of the shaft caught fire and spread to the breaker above. The miners died in the fire. This led to laws that a mine was to have at least two entrances.

The colliery and mine were built into the hill. The former DL&W railroad line ran alongside it. The railroad right-of-way is now a rail to trail. The wide gap in the trail is where several sidings that were used to handle coal cars. The Plymouth Historical Society maintains the grounds. There are several benches. They have also planted shrubs and flowers here.

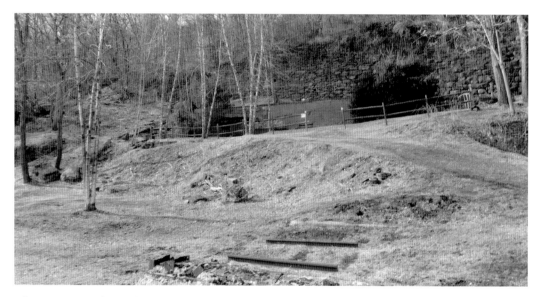

Above: A view of Avondale Memorial Park.

Below left: A mine opening and "Bat Gate."

Below right: An informational sign at Avondale site.

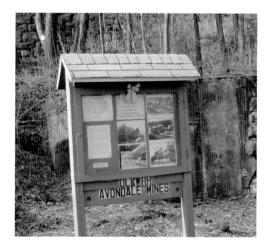

"Avondale Adventures" in the Washburn Street Cemetery

Through researching and reading about the Avondale Mine Disaster, the author found out that many of the victims were buried in the Washburn Street Cemetery in Scranton.

There are several historical markers in the Washburn Street Cemetery. It is a very old cemetery, originally called the Hyde Park Cemetery. Some workers pointed me to the Avondale Mine Disaster plot.

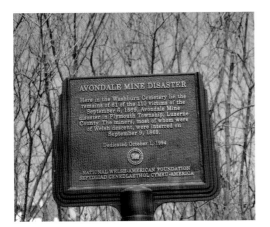 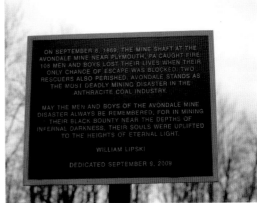

Above left: National Welsh-American Foundation historical marker.

Above right: The historical marker dedicated in September 2009.

Below: A view of a cemetery looking toward Avondale plot.

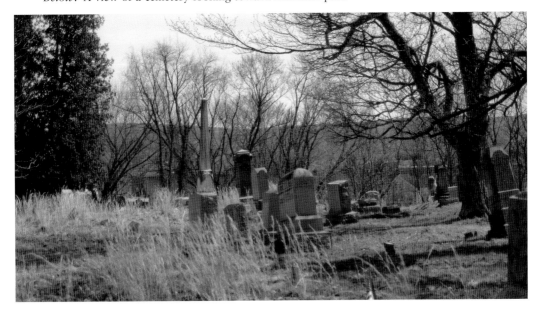

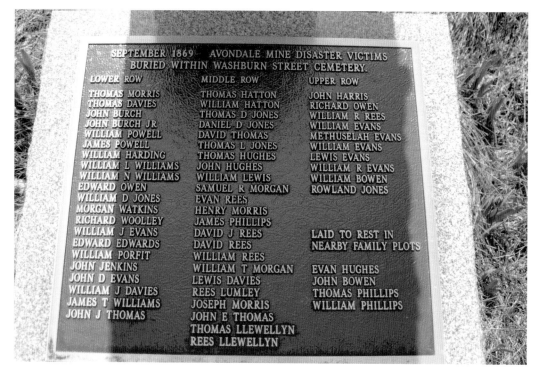

Disaster victims.

Belair/Babylon Colliery

Off of South Main Street, across the Lackawanna River, old coal lands go from Duryea into Old Forge, PA. More recently, the operation was known as the Belair Colliery. A listing in the yellow pages from the late 1990s listed it as "Belair Yards." In years past, the Babylon Colliery operated near here. The name of the neighborhood in Old Forge where the breaker was located near was called Babylon. The site is currently vacant.

Opposite above: Belair/Babylon colliery site.

Opposite middle: Close-up of a breaker.

Opposite below: Equipment on former the Belair/Babylon site.

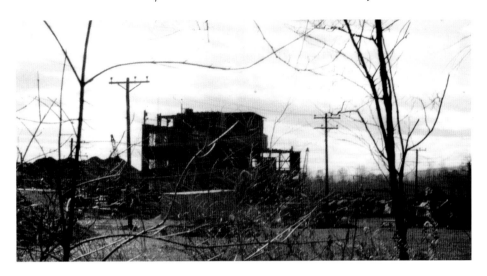

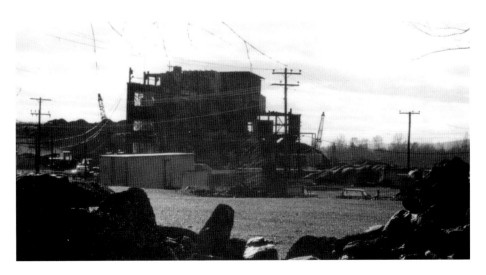

Demolition of Dorrance Fan House

In April 2021, the long-awaited demolition of the Dorrance Fan House off of Courtright Street in Wilkes-Barre started. This was part of the Lehigh Valley Dorrance Colliery.

When the brick was peeled away, a huge fan was revealed. The fan part was actually planks or beams. It was thick wood. The fan structure kind of looked like a Windmill. It must have produced a very strong stream of air when it was in operation.

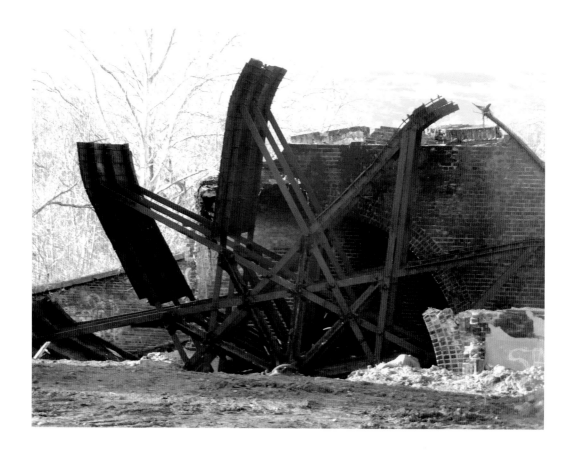

Opposite above: The demolition of Dorrance fan house.

Opposite below: Brick peeled back revealing a fan.

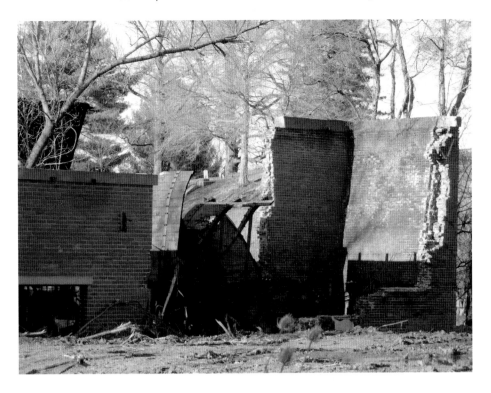

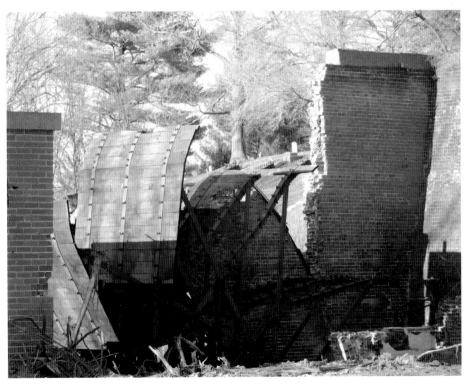

Movie Prop Breaker at Eckley

In September 2022, the author was able to visit Eckley Miners Village to see the old breaker.

The model breaker still stands in Eckley Miner's Village. It was just a movie prop, built for the movie *The Molly Maguires*. It never was a real coal breaker. It was a good depiction of the wooden coal breakers of that time period.

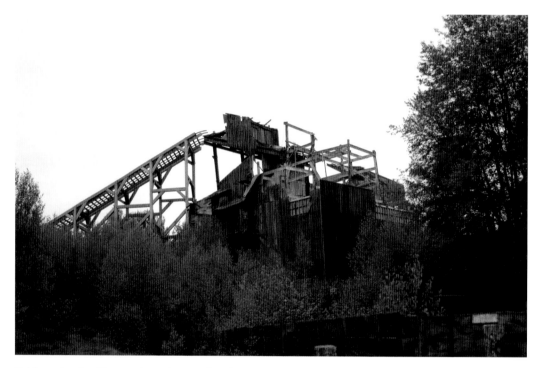

Eckley miner's village and movie prop breaker.

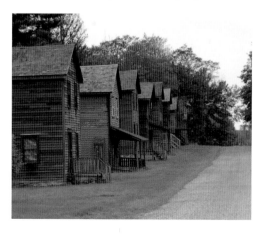

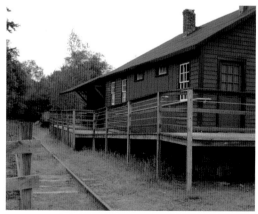

Gravity Slope Colliery Remains, Archbald

Back in 2005, the author went on a tour with Chris Murley and the Underground Miners. Chris and his group pointed out some historic landmarks.

In Archbald, there are the remains of the Gravity Slope Colliery. The largest building was a wash house. Later, it was used as a repair shop. There is an oil house and fan house. It still has a Guibal fan inside it.

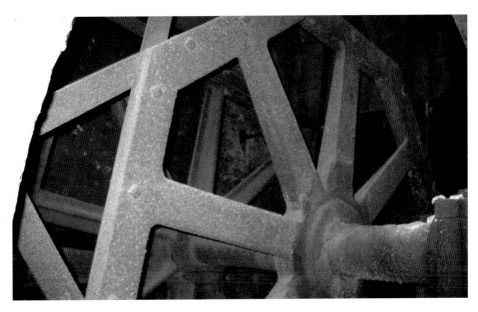

Views of the Guibal fan.

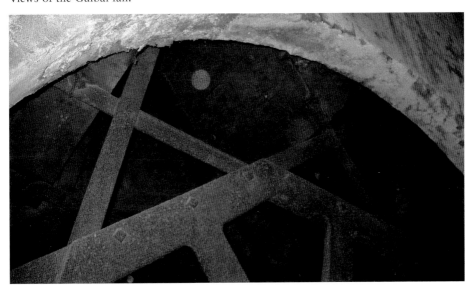

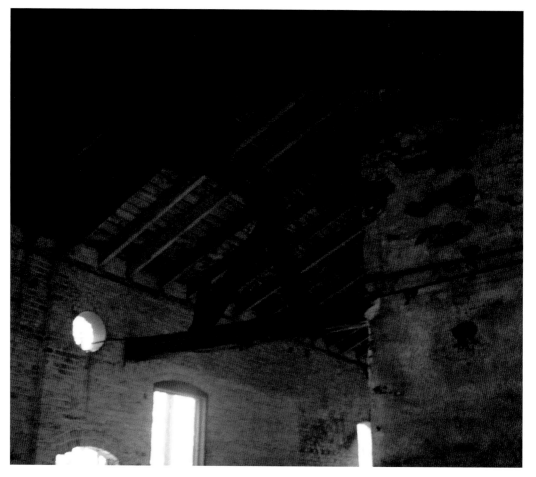

A roof showing beams and woodwork.

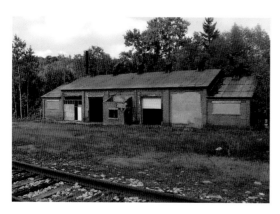

Above left: The wash house.

Above right: The oil house.

Harry E. Colliery

These photographs were from further up "The Back Road." The top of the breaker sticks out about the trees. The coal chutes going across the road make for an interesting scene.

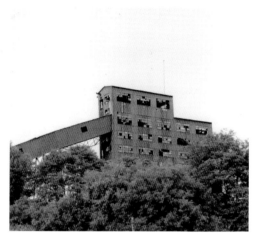 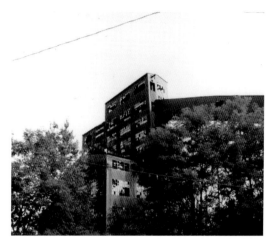

Above left: The top of Harry E. Breaker.

Above right: The slant view of Harry E. Breaker.

Below: Late 1980s Monte Carlo drives under breaker.

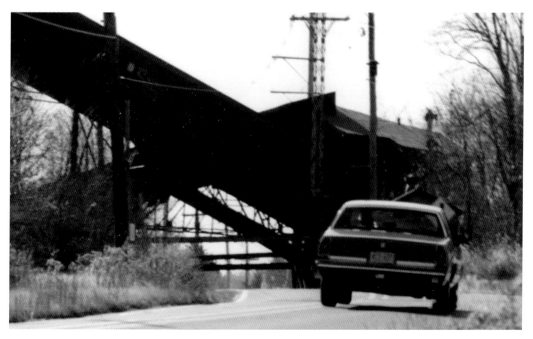

On the top of the culm bank is a little shanty with some machinery in it. Often at the top of the waste bank was a little shack. An operator sat in it and directed the flow of rock and gravel so the culm bank would grow evenly.

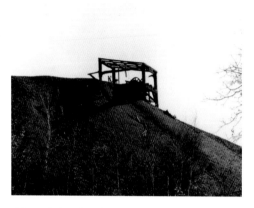 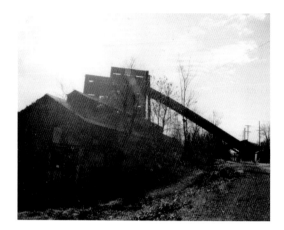

Above left: The shanty on top of culm bank.

Above right: The boiler house and Harry E. Breaker.

Below: Equipment at the breaker site.

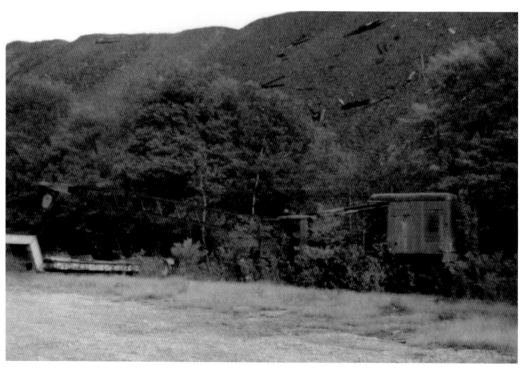

Huber Breaker Power Poles and Distribution Towers

It was said that the Huber Breaker powerhouse was so efficient that it sold surplus power. These poles and distribution towers were remains of a power distribution line heading south through the Preston section of Hanover township. These towers were removed when the Huber culm bank was cleaned up a few years ago.

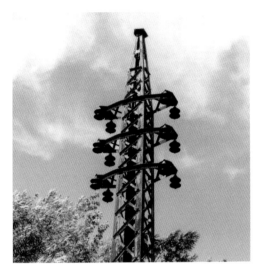
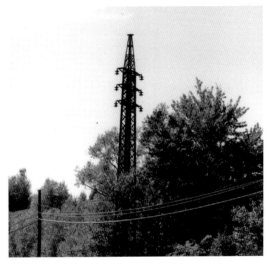

Old power distribution poles and towers.

Huber Breaker Side View

Here are some side views of the old Huber Breaker. The first photo is from the Preston section of Hanover Twp looking toward Ashley. In the foreground are piles of the culm slurry that the Huber Breaker used to dispose of its waste material.

The unmarketable coal and culm were mixed with water to form a slurry that was pumped in pipes down the road to the large Huber Bank in Preston. At this point in time, the breaker, powerhouse, and other buildings are still standing.

The next photo shows the little bridge that carried this piping across the Central Railroad of New Jersey tracks.

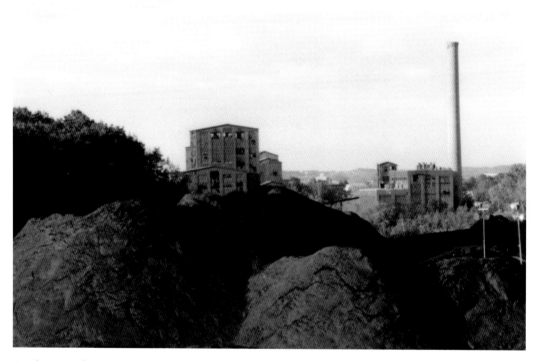

A side view of Huber with culm pile in the foreground.

Opposite above: Bridge carrying pipes across the CNJ rail line.

Opposite below: View of Huber from Franklin Junction.

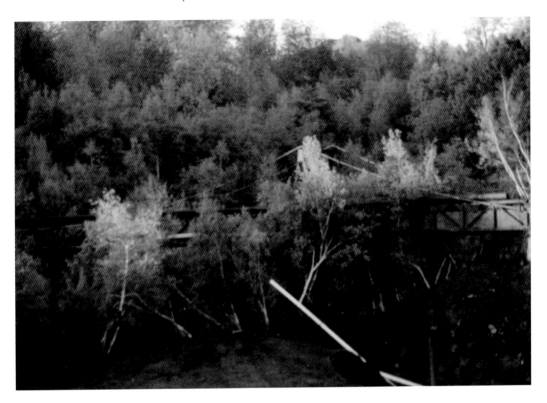

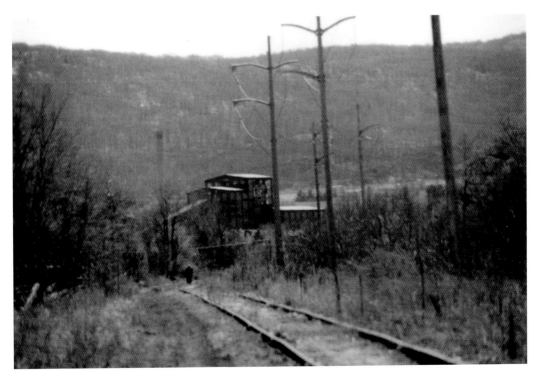

Lion Coal Company Breaker/Hazleton Shaft

Some different views of the of the Lion Coal Company Breaker, also known as the Hazleton Shaft. These show the ruined coal lands, almost like a Lunar Landscape. These shots are from the early 1990s. It was an overcast day.

The headframe was still standing. This had the machinery to raise and lower the elevators to move the miners and coal in and out of the mine. The breaker was demolished in 1996.

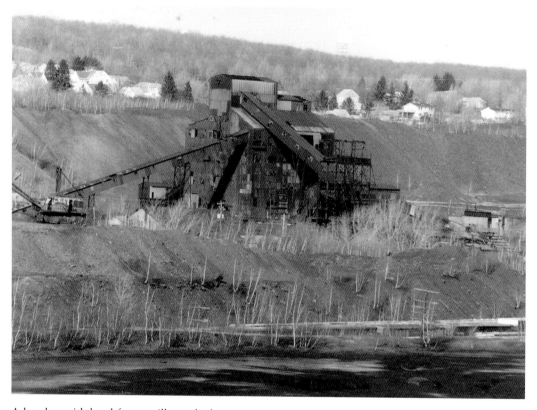

A breaker with head frame still attached.

Opposite above: Outbuildings and equipment at Hazleton shaft site (Lion Coal Company).

Opposite below: Outbuildings and crane.

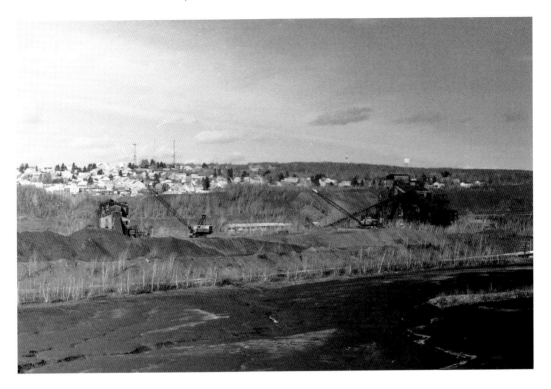

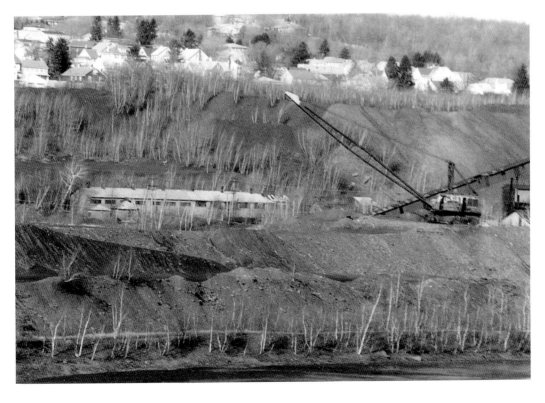

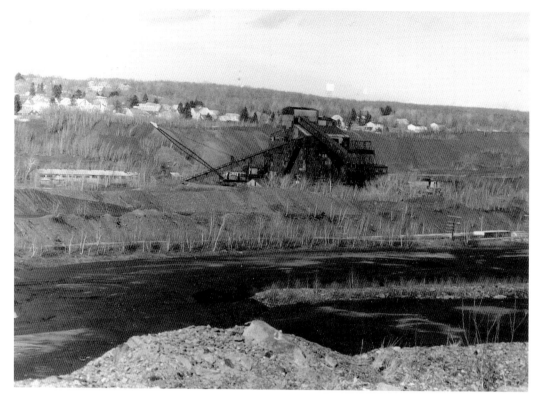

Above: A breaker with coal dump in the foreground.

Below: An overview of the site.

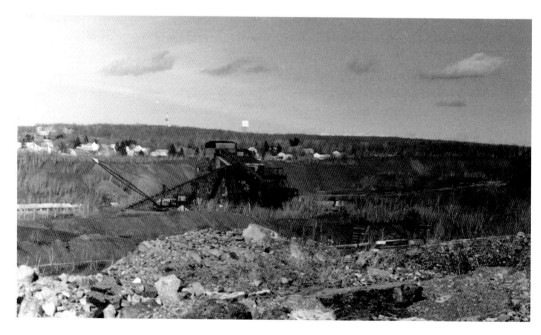

Loree Colliery Remains

The author missed the demolition of the main Loree Breaker some years before these photos were taken. These were taken in about 1993—at the time, only some outbuildings and other structures remained. Trees have grown into many of the brick buildings.

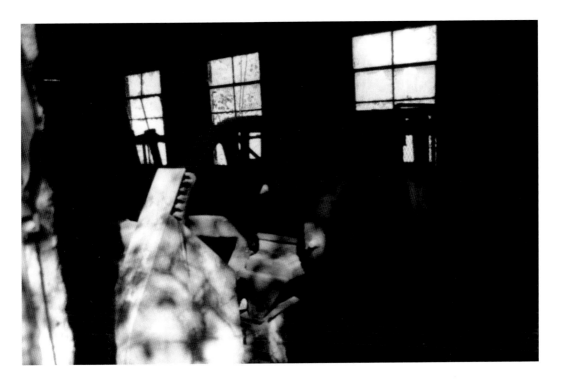

Above: Machinery in an abandoned building off of Nesbitt Street in Larksville.

Right: A concrete support stands along the side of the road.

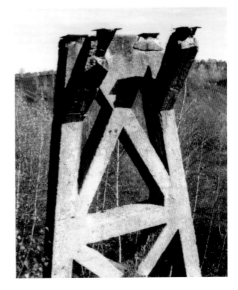

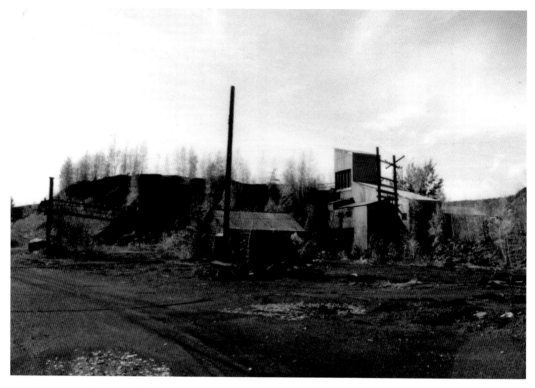

Overgrown buildings and equipment at Loree site.

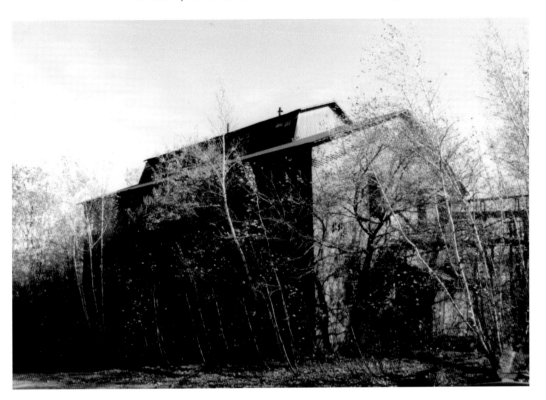

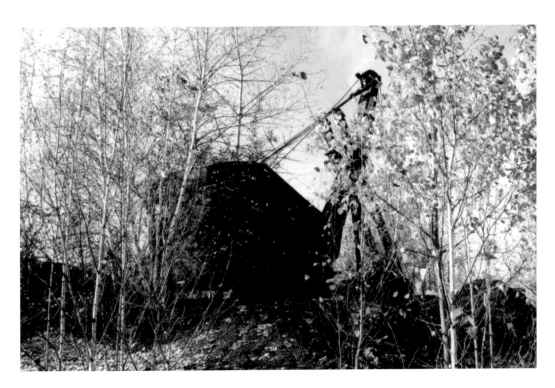

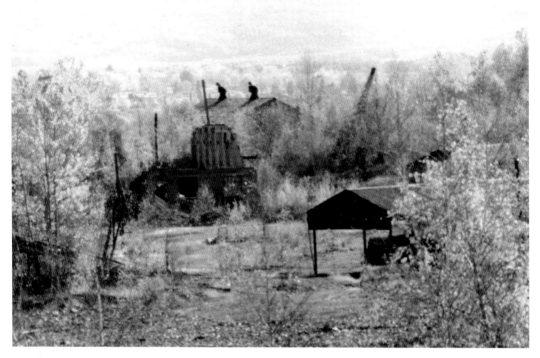

Overgrown buildings and equipment at Loree site.

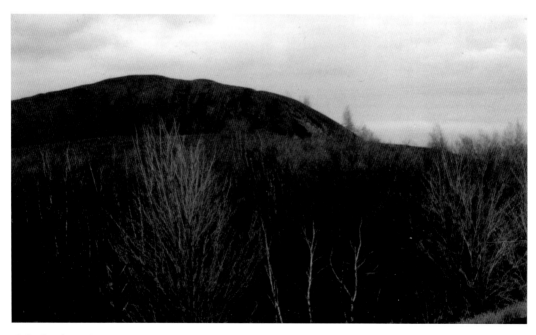

Culm bank at site.

Lost Vein Coal Company

Sometimes, the best photos happen on accident. This is an example: the author was taking a ride to Shamokin. Just before Shamokin, there was a coal breaker. Their "processing plant" looked like an old-time coal breaker.

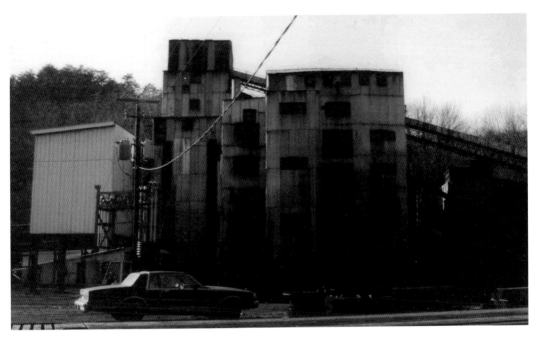

Lost Vein Coal Company.

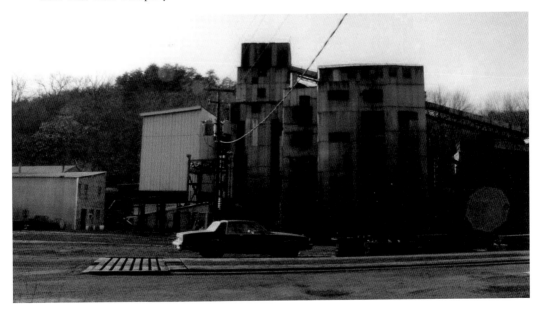

Moffat Colliery Powerhouse

This brick building was used to house some of the switchgear for the breaker. Control panels, switches, disconnects, circuit breakers, and other equipment would be located in this building. Such a building would be used to control equipment like transformers in an outside switch yard.

Above left: Inside the Moffat Colliery powerhouse, with insulators still hanging on the walls.

Above right: The interior showing switchgear and broken windows.

Above left: The powerhouse in front of remains of the concrete coal breaker.

Above right: A side view of powerhouse and debris pile.

Moffat Colliery Remains/Machinery

Various parts of machinery lay in the rubble pile: wheels, gears, funnels, crushing devices, etc. The photos are from about 1987, shortly after the concrete breaker was demolished.

In 2021, Taylor Borough was donating some pieces of machinery, grinders, wheels, gears, etc. to the Anthracite Museum at McDade Park.

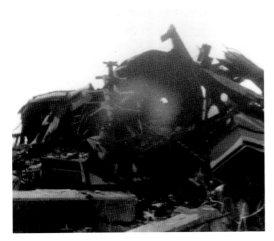

Above left: Machinery, cleaning cones, and gears at Moffat site.

Above right: Parts of machinery on floor of a building.

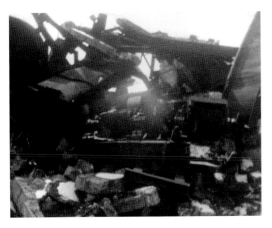
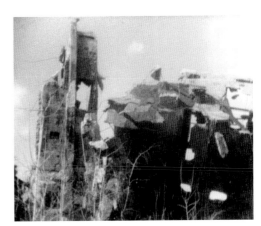

Above left: More machinery and girders.

Above right: Concrete from the Moffat breaker.

New County Coal Company

The back of this property bordered Parsonage Street. New Street formed another border. This is the a modern "Processing Plant" or breaker used to crush the coal into various sizes. In the background are the culm dumps of the old No. 9 Colliery.

 The property is now vacant. If you look carefully in the photo, behind the culm bank is a drag line shovel.

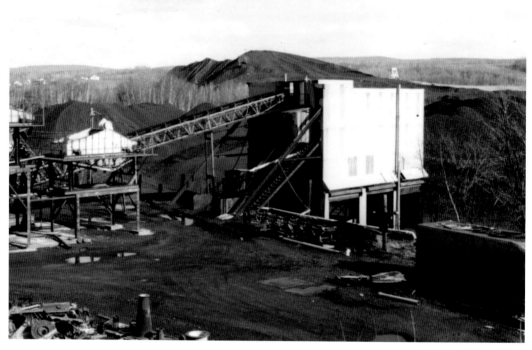

View of New County Coal.

Pine Ridge Air Shaft Opens Up

After the Sullivan Trail Coal Company removed most of the coal and the culm from the former Pine Ridge Colliery Site, there was a large parcel of land left.

Senior high rises and single-story ranch houses were proposed. Then in the late 1980s, an 80-foot-deep air shaft opened up. The shaft was filled and capped with dirt and crushed stone. The kids would use the cap as a ramp for their dirt bikes and ATVs.

Capped Pine Ridge air shaft in front of the wash house.

Pine Ridge, After Reclamation

Some "after" views of the Pine Ridge Colliery Site after reclamation. The red ash and coal rock have been removed and graded. Remains of buildings and other rubble have been cleaned up. The area that was the silt pond has been filled in with rock and clean fill.

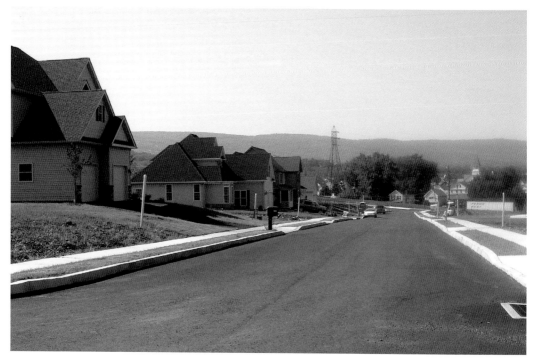

"After" views of Pine Ridge site.

Pine Ridge Red Ash Banks

Red ash is what is left over after culm banks burn. There were some huge piles of red ash along Mayock Street and Stucker Street, in the Parsons section of Wilkes-Barre. There is still a little bit of this red ash left. This was like a playground for the neighborhood kids.

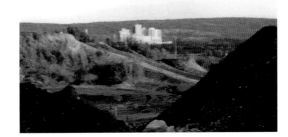

Red Ash banks at Pine Ridge site before grading.

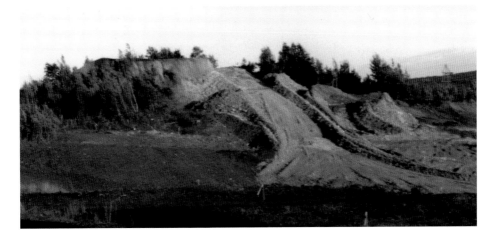

Pine Ridge Wash House

The only building left in later years was at the Pine Ridge Colliery Site in the Miners Mills section of Wilkes-Barre was the wash house. The front part had those little pulleys on the ceiling that the miners would use to hoist up their wet, dirty clothes and boots.

A few people wanted the wash house preserved, but it was demolished. There are now town homes in front of the site.

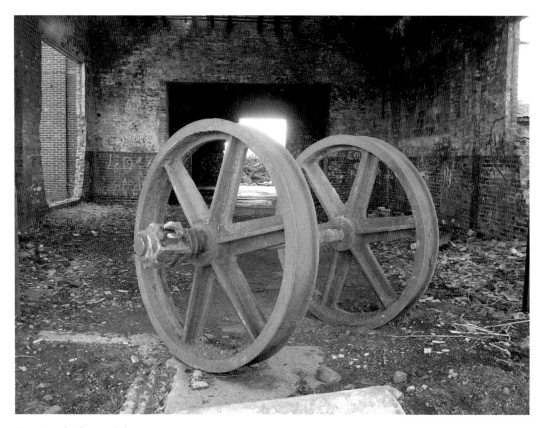

Gear inside the wash house.

Opposite above: A missing roof, showing a pulley system used to hang wet clothes on.

Opposite below: The wash house during a snow squall.

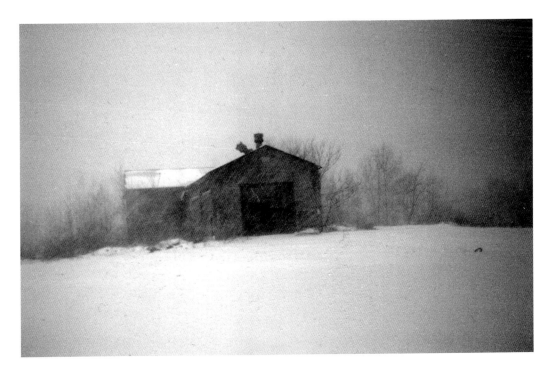

Storehouse/Mule Stables on Thompson Street

This building off of Thompson Street in Pittston was from the Pennsylvania Coal Company. This long brick building was used as a storehouse and mule stables. At one time, the mules were used to pull the coal cars in and out of the mines.

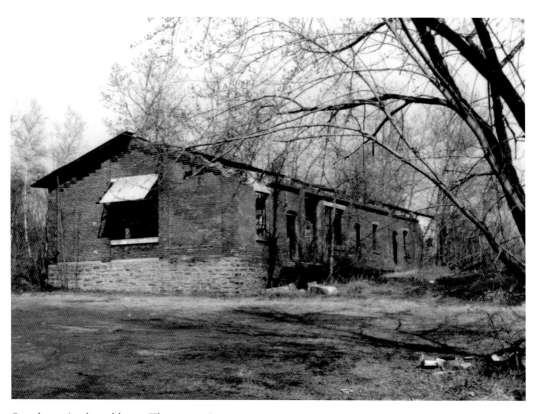

Storehouse/mule stables on Thompson Street.

Shamokin Mine Buildings

Back in the early 2000s, the author took a ride to Shamokin. On Rt 61 outside Shamokin, there were some mine buildings. The black building housed some sort of equipment for the mines—fan or pump equipment. The buildings behind it were said to be shops and wash houses for the miners.

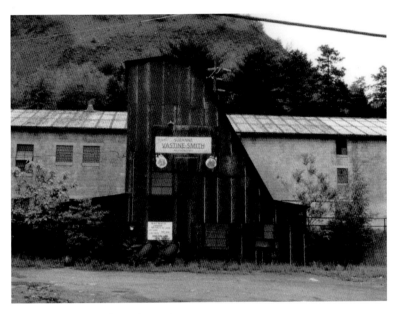

Mine buildings in Shamokin, PA.

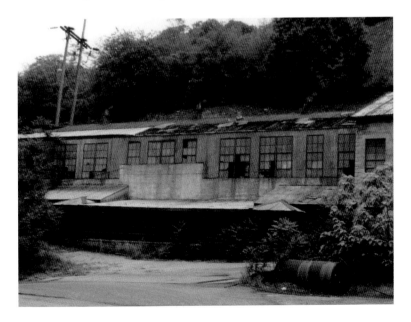

Sullivan Trail Minus the Breaker

These photos show the Sullivan Trail Colliery, minus the breaker. The buildings that housed the machine shops are still there. Much of the trucks and heavy equipment have been removed from the site.

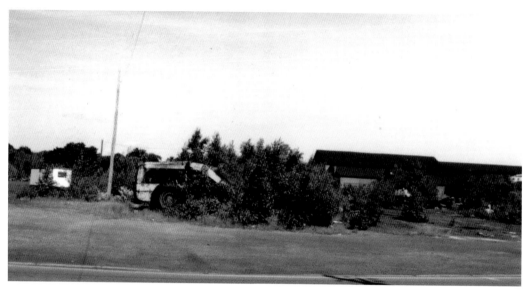

Sullivan Trail Breaker gone but not forgotten.

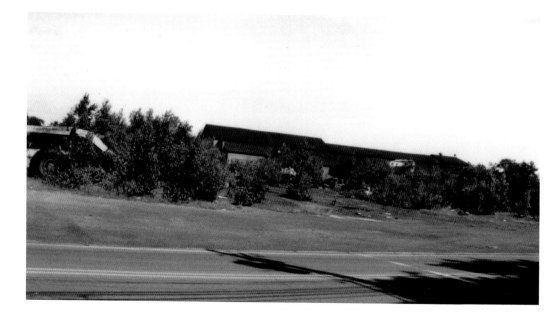

Sullivan Trail Breaker from Pittston Junction

The author stopped to look at some flooding in the Pittston Junction. Much of the railroad tracks had been covered with water from the Lackawanna and Susquehanna Rivers.

The Sullivan Trail breaker, as well as the high rise in West Pittston, is visible in the background.

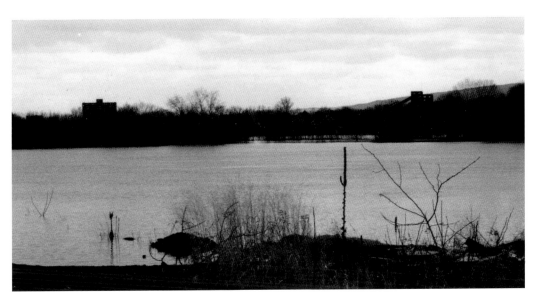

Sullivan Trail during a high-water event.

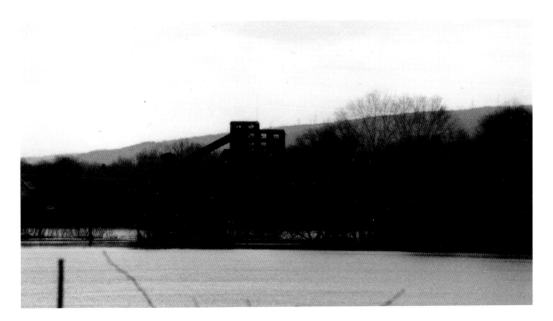

Twin Shaft Foundations

The Twin Shaft Colliery was located in the Pittston Junction. This was the site of the Twin Shaft Mine Disaster. According to the historical marker, fifty-eight men were killed by a cave-in on June 28, 1896.

For many years, these foundations were hidden from view by trees. When the R&N Railroad expanded, the foundations were demolished. The historical marker is close to the Twin Shaft foundation site.

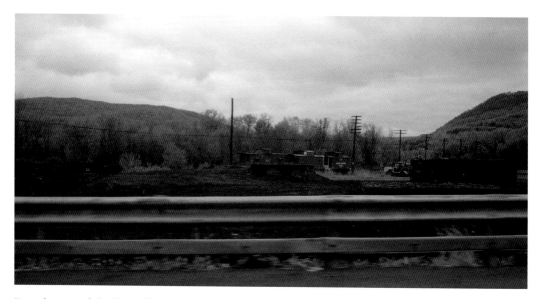

Foundations of the Twin Shaft Coal Breaker.

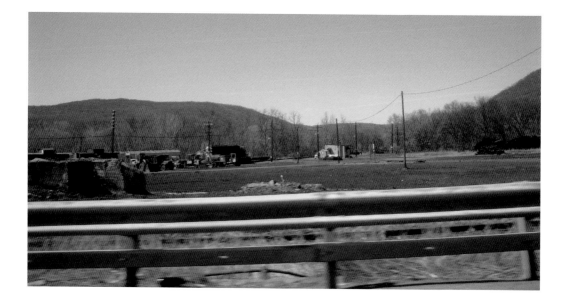

Waddell Breaker Site

These are late-1990s views of the Waddell Breaker Site in Archbald, PA. At this point in time, a lot of interesting things still remained here—such as landlocked coal hoppers and some heavy equipment, including excavation cranes, pay loaders, and trucks.

What was left of the breaker still stood on the site. Just crumbling pieces of it remained.

The company is noted for painting several hopper cars a bright orange color, with the writing "Waddell Coal Mining Co, Inc.," "Winton, PA," and "Chance Cone Cleaned."

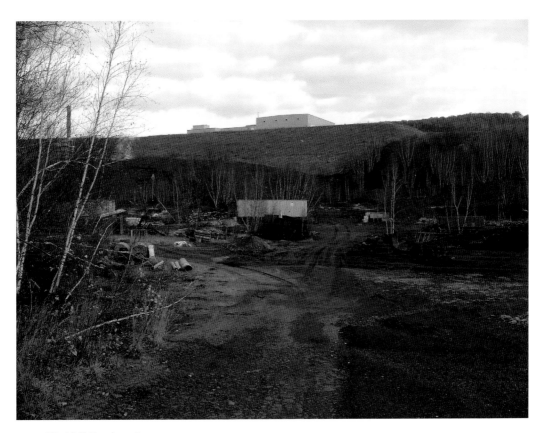

Waddell Breaker site.

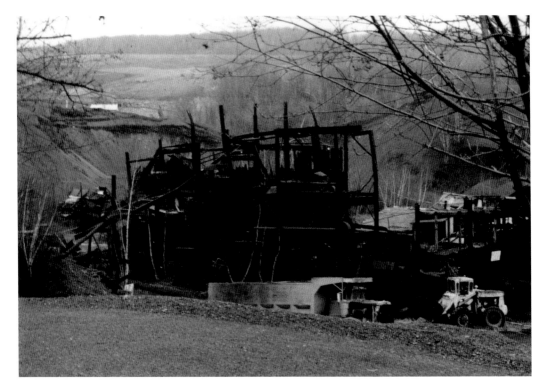

The shell of a breaker.

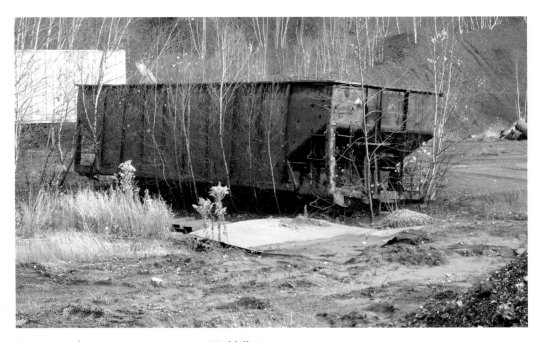

Hoppers and remaining equipment on Waddell site.

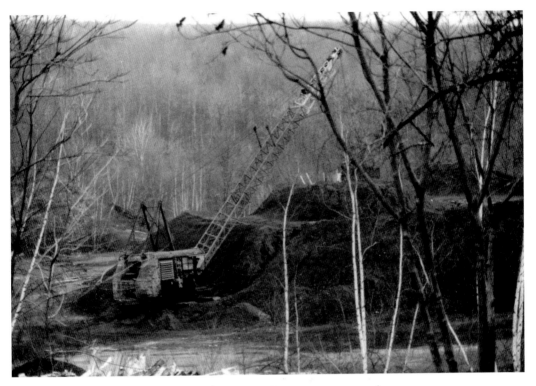

Hoppers and remaining equipment on Waddell site.

Hoppers and remaining equipment on Waddell site.

PEI Energy Plant

The author found this by "accident." Walking along the Lackawanna Valley Heritage Trail, there were side streets to explore. Various remains of trestles were to be found. Some rails were still in the street. A short distance away the abandoned workings of the Waddell Breaker were still standing.

Up on top of the hill was a Cogen plant. It was the PEI Energy plant. It anchors the industrial development, called PEI Power Park. PEI's website says that the plant was originally built to burn culm and coal but was converted to burn gases from nearby landfills.

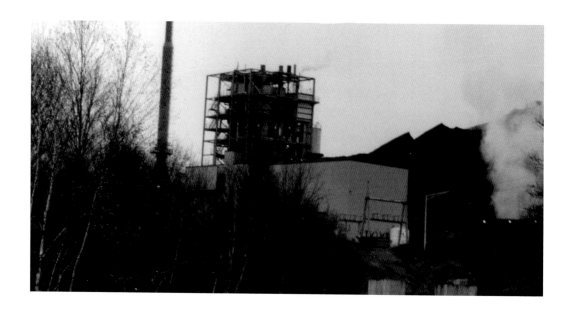

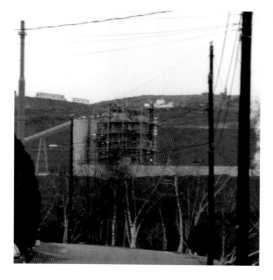

PEI energy plant.

Company Housing

Concrete City, Panoramic Views

The houses of the Concrete City in the Hanover section of Nanticoke are shown here, minus much of the graffiti and artwork painted on them today. An innovative housing solution, they lacked indoor plumbing and were very damp inside.

The shots date from the late 1990s, and while the area is known to locals, it had not been "on the radar" to adventure seekers on the internet or social media.

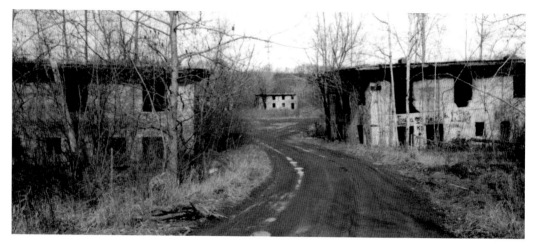

Panoramic views of Concrete City.

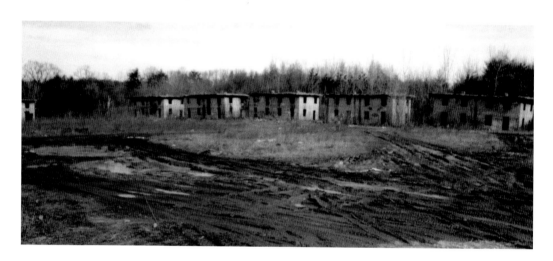

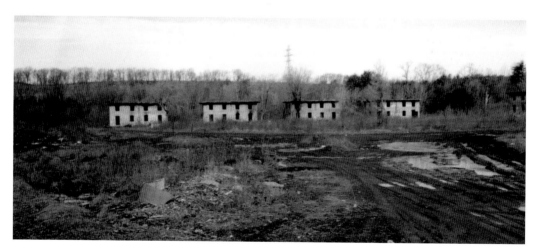

Company Homes, Page Avenue Kingston

When the author attended King's College in Wilkes-Barre, the late Dr. Hanlon taught a history course. Dr. Hanlon had some novel assignments to perform. We were on the chapter about the Industrial Revolution. The subject of coal mining came up. We talked about patch towns and company housing. The assignment for that weekend was to go to Page Avenue, Kingston, and look at all the homes. Most were originally company homes. They all look pretty much the same, although many have been remodeled through the years.

Ethnic Neighborhoods, Towns, and Patches

With all of the different nationalities and enthicities of the people who moved to the region to mine coal, they settled in thier own communities.

You could mention the name of the neighborhood or town and know what ethnic group was donimant there. Pittston was Italian and Lithuanian, some German. If you said South Wilkes-Barre or the Heights, Lebanese, Syrians, and Polish settled there. The East End of Wilkes-Barre was mostly Irish. At one point, it was called Five Points, probably after the Five Points area of New York City. Many of the Irish that came to the East End were from Five Points NYC. Eventally, the name got changed to East End.

The North End of Wilkes-Barre had a lot of Slavic people living in it. At one time, there was a Slovak Roman Catholic Church, a Polish Roman Catholic Church, a Ukranian Greek Catholic Church, a Byzantine Rite Church, and a Russian Orthodox Cathedral.

In Plains township, there was a section of Hudson called Irishtown. It was a little patch, with only three streets in it. A sign was recently hung to mark the location.

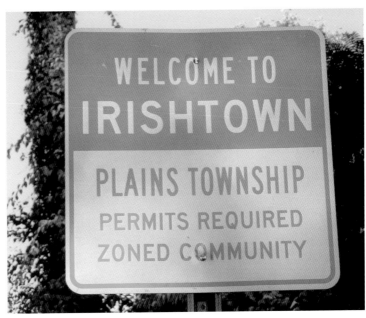

Irishtown section of Plains Twp.

The Ruined Landscape

Solomon's Creek Acid Mine Drainage

Solomon's Creek is contaminated with acid mine drainage. Sulfur, iron, and other minerals dissolved in water discharges from mine openings into the creek. The trees along the creek are covered in "yellowboy" (the discoloration from acid mine drainage). Even the surrounding woods have the yellow tinge on the trees, from when the creek would flood.

Solomon's Creek is a shade of rusty brown.

Acid Mine Drainage, Confluence of Lackawanna and Susquehanna Rivers

Low water reveals the effects of acid mine drainage where the Lackawanna and Susquehanna Rivers make thier confluence. Rust orange stains the rocks, trees and other objects. An outfall near Old Forge, PA, pollutes the Lacakawana with acid mine drainage.

Rust-stained rocks from acid mine drainage on a dreary, cold day.

Culm Dumps, North Main Street, Pittston

Off of North Main Street in Pittston, PA, there are culm dumps. Waste piles of unmarketable coal and slate and other rock. Just one of the many culm or refuse piles left over from the anthracite industry in the region.

 Living in the region, you just sort of ignore these scars of King Coal's glory days. It just sort of blends in with everything.

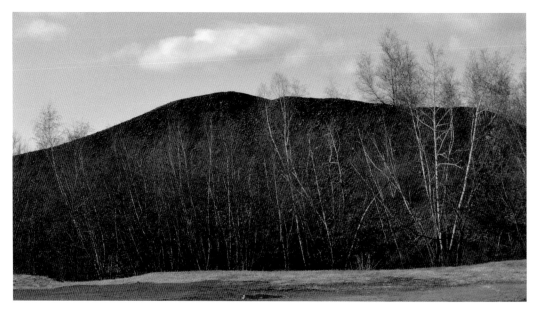

Reminders of King Coal, off of North Main Street, Pittston.

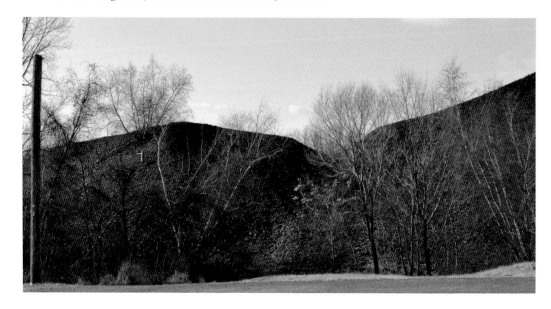

Culm Banks Along Lackawanna River

As you head over the bridge into Old Forge PA, there are culm banks along the Lackawanna River. They start behind a car wash and extend toward Duryea. The culm goes right into the river. A broken retaining wall and some concrete blocks are near the bottom of it. For decades, the heavy metals and acid leached out of this culm bank and into the Lackawanna River.

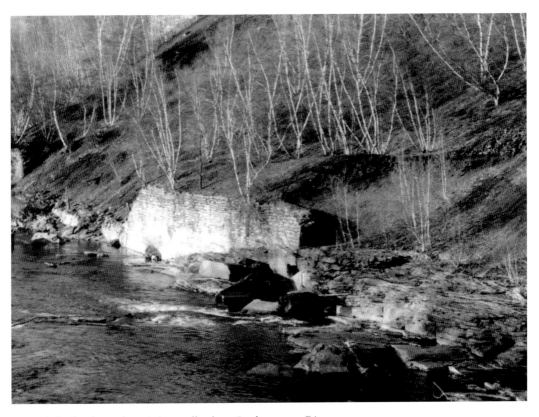

Culm banks and retaining walls along Lackawanna River.

Mocanaqua Loop Trail

Here is a good example of mine-scarred land. A few years ago, the author took his nephew to the Mocanaqua Loop Trail. We wanted to go to the overlook, but we went the wrong way because the trails were not marked.

We ended up at some huge culm dumps known as "The Five Fingers." The culm dumps resembled the surface of the moon.

A historical marker down the road explains that Mocanaqua was a company town for the West End Coal Company. The town was the Native American name given to Frances Slocum after she was kidnapped by the Delaware tribe after the Battle of Wyoming.

Culm bank in the forest.

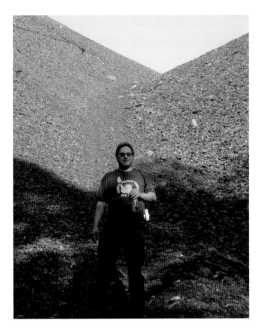

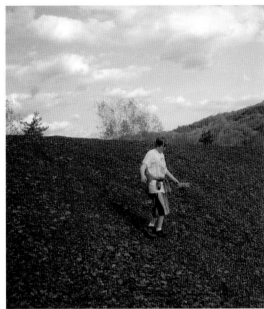

Above left: Author by a culm bank.

Above right: The author's nephew.

Below: Historical marker.

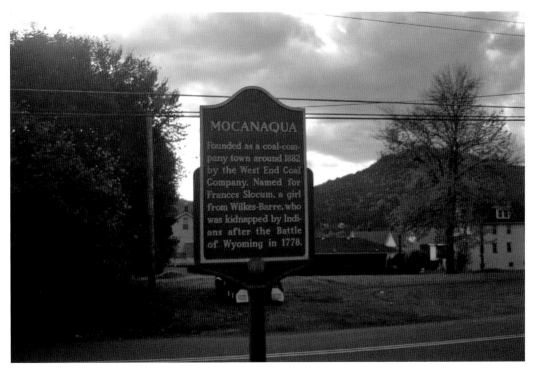

Prospect Bank Half Gone

Here we see the Prospect culm bank almost half gone. A mobile processing plant (the modern term for a coal breaker) was set up in the late 1990s. Slowly over time, the coal pile got smaller and smaller.

Above left: Prospect Bank half gone.

Above right: Prospect reclamation operation.

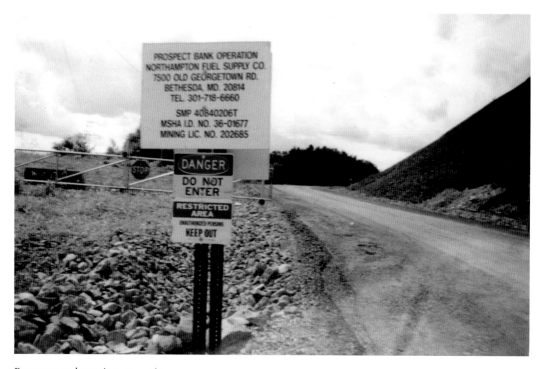

Prospect reclamation operation.

Prospect Culm Bank, Before and After

These photos show a before and after view of the Prospect culm bank in Plains, PA. This pile of coal, slate, and shale was left over from the Prospect Colliery's mining operation. It was a huge black hill that dominated the Wilkes-Barre and Plains skyline.

Eventually, the land was reclaimed. Coughlin, Myers, and GAR formed the Wilkes-Barre Area High School. The new school was built on the former Prospect Colliery culm bank site.

The pile was higher in the 1980s. Slowly, over the years material was removed until the bank was cleared in the late 1990s–early 2000s.

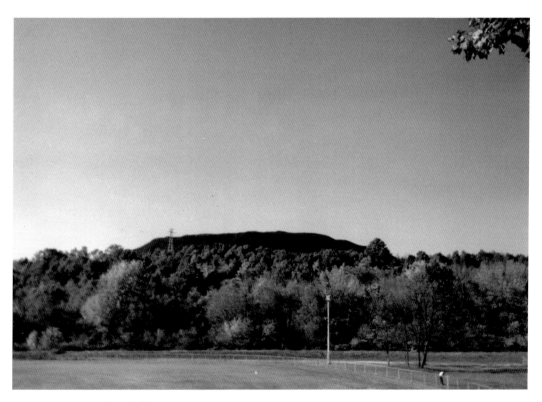

Prospect Bank in fall.

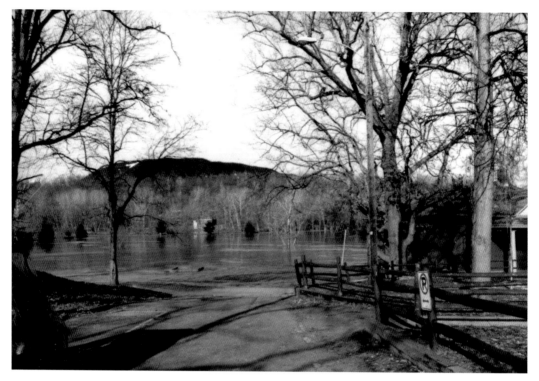

Prospect Bank during flooding.

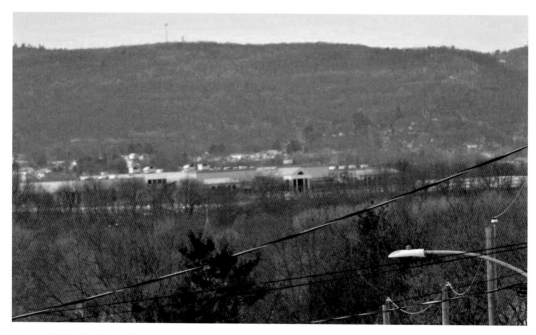

A new high school on the site.

Garment/Textile Industry in NEPA

Garment and Textile: Sister Industry to Anthracite

At one point in time, the garment/textile industry had a huge presence in Northeastern PA. Silk mills and dress factories were as numerous as coal breakers. It was generally seen as a way to employ the other family members of the coal miners. Mostly, the women and young girls were working sewing dresses and other articles of clothing.

Throwing mills, lace works, dress factories, and other textile-related concerns sprouted up. This industry was a major employer in the region until the mid-1990s, when production moved out of the country to places like India, Mexico, and Honduras.

The author's father worked making belts for Penn State Belt and Buckle and Atwater Throwing. One summer, he got in on a rush job to make Banlon. Another time, he was a bobbin boy replacing the bobbins and thread for the machines. The author's father also noted there were many shoe factories in the Wyoming Valley. People could make good money working piecework in a shoe factory or silk mill.

Probably one of the most famous silk mills in the area was Scranton Lace. This was near Mylert Street in Scranton. The major feature of this building complex was a clock tower. It looked like a steeple. Scranton Lace made lace curtains and tablecloths. It closed in 2002. Abandoned for many years, it is being redeveloped into loft apartments.

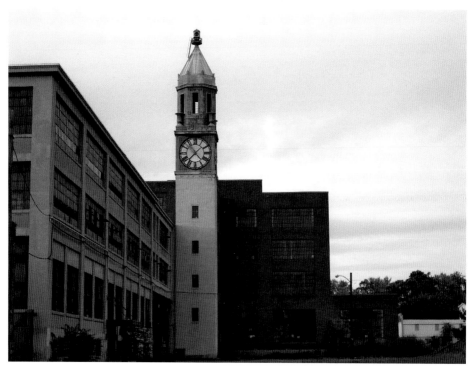

Scranton Lace.

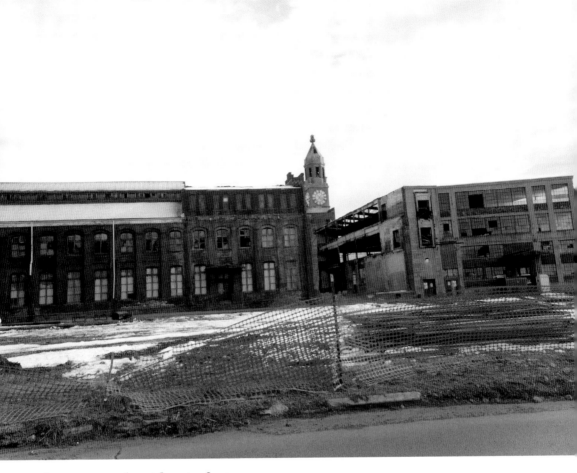

A new construction at Scranton Lace.

Another large complex was the Wilkes-Barre Lace Manufacturing Company on Darling Street. By the 1970s, it was subdivided into retail/offices. By the late 1990s, much of the complex had been vacant for many years. The author recalls that the last tenants moved out in the late 1990s. In October 2007, a massive fire, started by homeless people, destroyed most of the complex. The author was at Sacred Heart Slovak Church. As the people left Sunday Mass, a huge "tornado of smoke" was off in distance a few blocks away.

After the fire, the building languished for a few more years before being demolished. A senior housing development was built on the property.

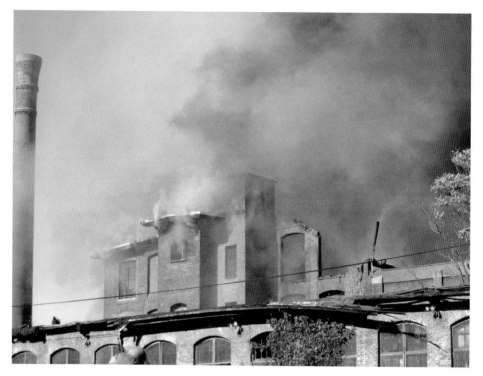

Wilkes-Barre Lace fire.

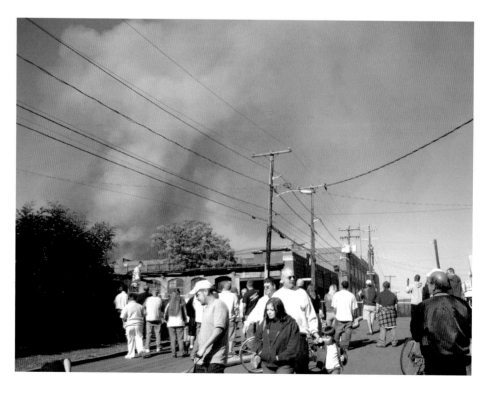

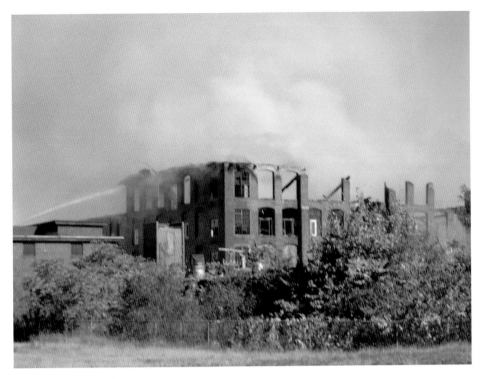

Wilkes-Barre Lace fire.

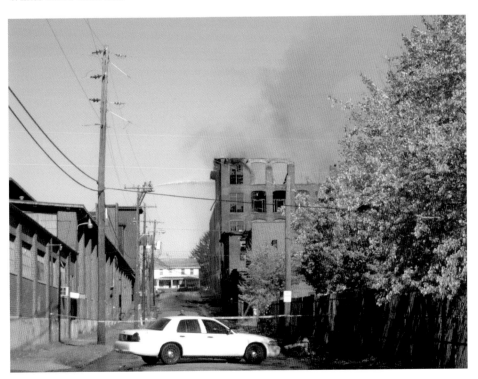

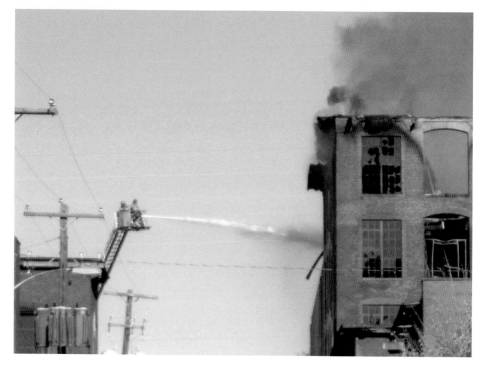

Wilkes-Barre Lace fire.

Senior housing at Wilkes-Barre Lace site.

Senior housing at Wilkes-Barre Lace site.

The Duplan Silk Mill in Hazleton was once the largest silk mill in the world. Today, it is subdivided into various tenants to make use of the large space. In the 1970s, the Duplan building was used as a shoe factory.

In downtown Wilkes-Barre, the ILGW Union had its Tri District Health Center, located across from the CYC (Catholic Youth Center).

Later, when the building was demolished, the terracotta panels of the garment workers were saved and moved down the street as part of the Labor and Industry building.

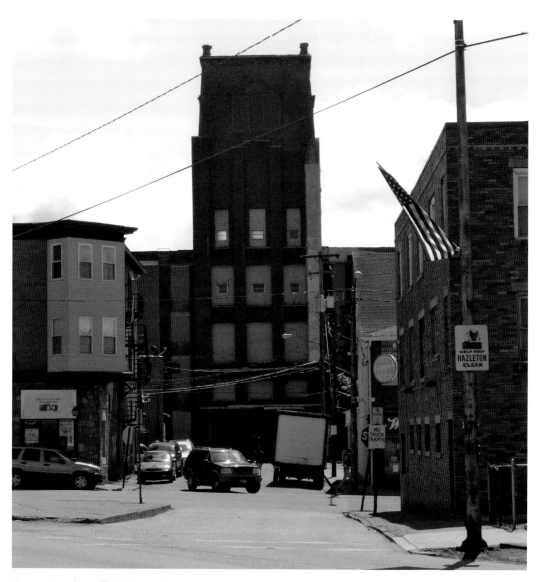

Former Duplan Silk Mill, Hazleton.

ILGW Tri-District Health Center.

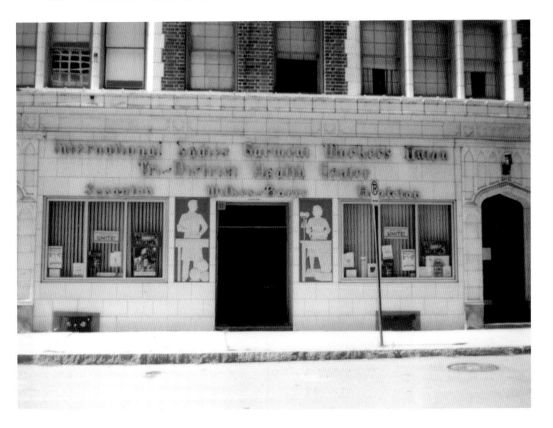

Historical Markers and Mural, Pittston

There are several historical markers related to the garment industry and the ILGW Union. A mural commemorates Pittston's mining and garment industry and railroad heritage.

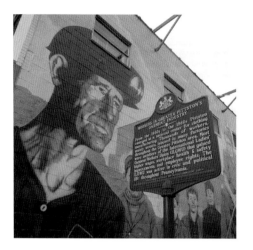 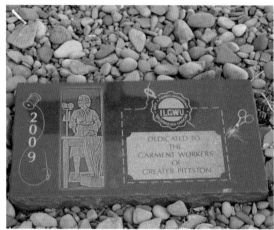

Historical markers and mural, Pittston.

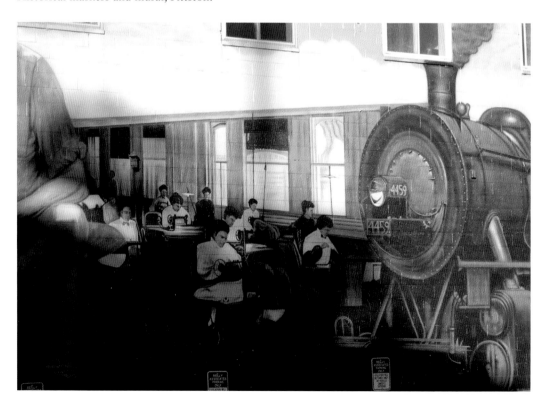

Conversion to Lofts and Mixed Use

Many cities have had these buildings re-purposed. For example, the Hess, Goldsmith and Company Broad Silk Mill on Schuyler Avenue in Kingston is now loft apartments, and well as mixed-use spaces. The former Empire Silk Mill has been converted to lofts too.

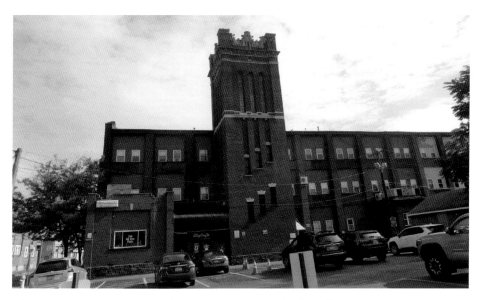

Above: Former Hess, Goldsmith and Company Broad Silk Mill.

Below: Former Empire Silk Mill.

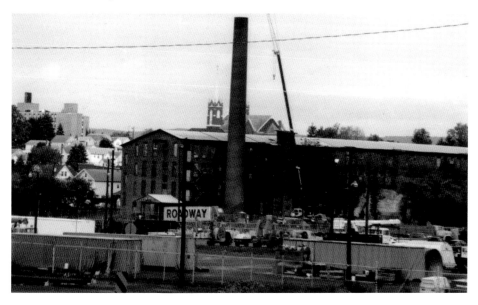

More Images of Silk Mills/Garment Factories

Here are some more images of the region's silk mills and garment factories. Many of these buildings have been reused.

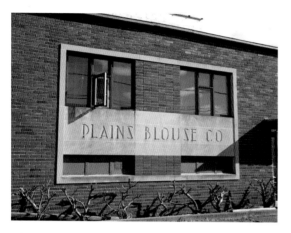 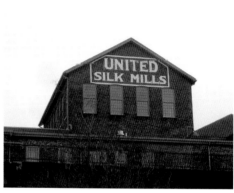

Above left: Plains Blouse Co.

Above right: Former United Silk Mills.

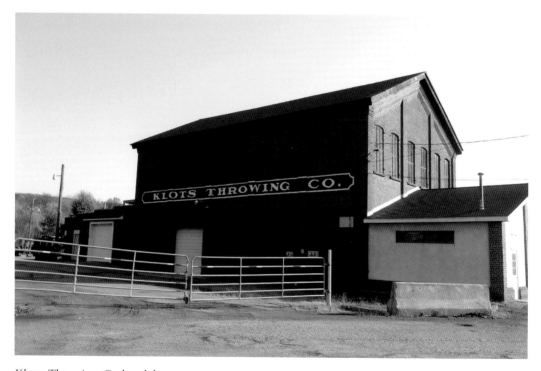

Klotts Throwing, Carbondale.

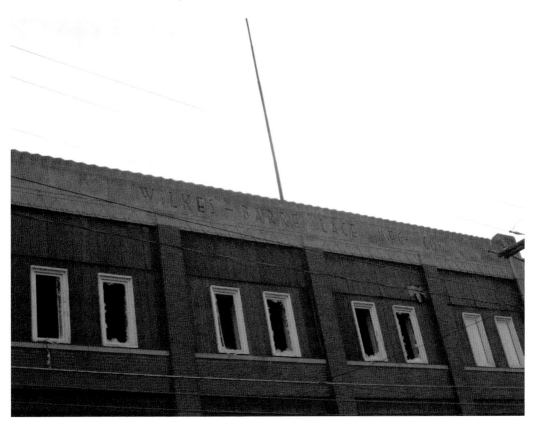

Wilkes-Barre Lace.

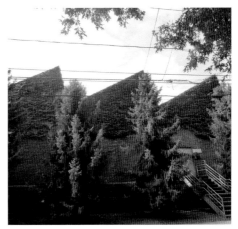

Above left: Harbor casuals in the Hudson section of plains, before demolition.

Above right: Former Dorranceton Silk Works in Kingston, PA.

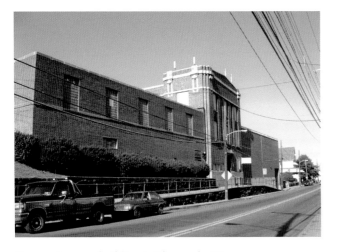 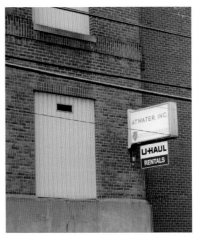

Former Atwater building in Plymouth, PA.

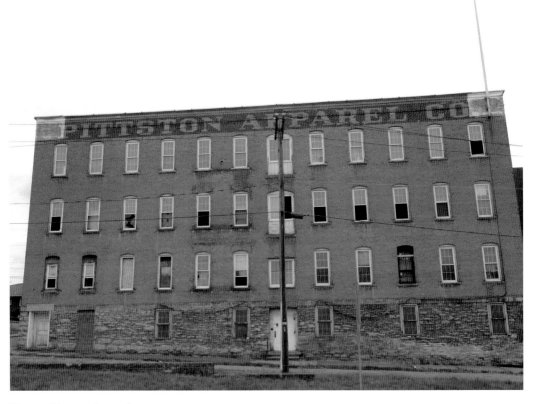

Former Pittston Apparel.

Historical Markers and Monuments

John "Blackjack" Kehoe's Grave

Every photograph has a story to it. One of the author's favorite movies is the *The Molly Maguires*. Being of Irish decent, it seemed a good thing to go look for on a Saturday. They said that the Mollies only operated in the southern coal field. It was said they did not go into the northern coal field.

 The author located St. Jerome's Catholic Cemetery and came in from the High Street side, walking and walking until the grave was located, close to Mahanoy Street. There is also a historical marker and informational signage nearby.

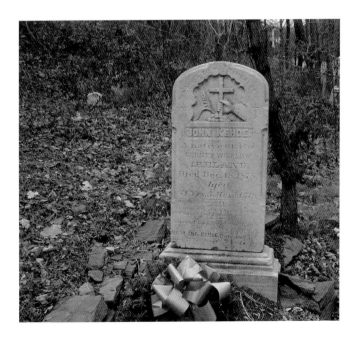

John Kehoe's grave.

Ellen Webster Palmer Memorial

This memorial to Ellen Webster Palmer formerly located on the River Commons in Wilkes-Barre, prior to reconstruction in 2006. The statues have some damage. In 2021, the county had announced that they will not restore this statue.

Palmer founded the Boys Industrial Association in Wilkes-Barre. Even though the statue has damage to the nose, it is interesting. They should display the statue again.

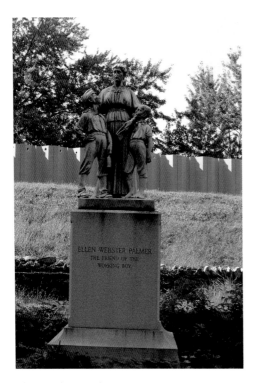 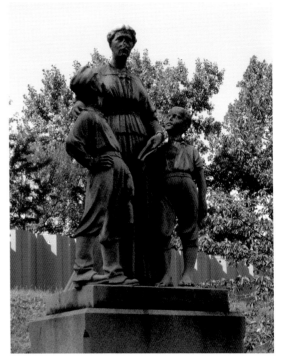

Ellen Webster Palmer statue.

Gravity Park Carbondale PA

At the end of the downtown area in Carbondale, there is Gravity Park. This little park commemorates the Gravity Railroad and the D&H with a PA state historical marker and a monument.

The historical marker and monument describe that the D&H Canal Company built the Gravity Railroad from Carbondale to Honesdale. It was one of the first railroads in the western hemisphere.

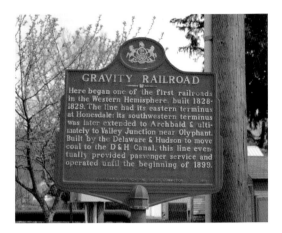

Gravity Park in Carbondale, PA.

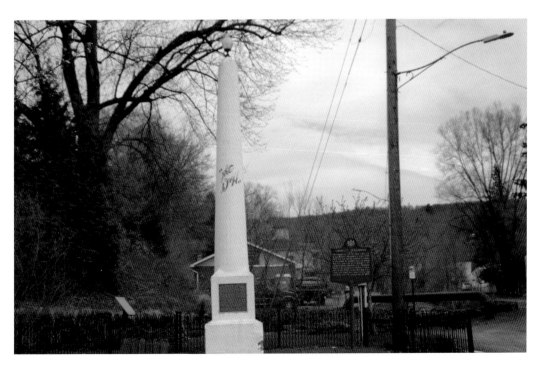

Transportation Systems

Relics of Transportation Systems

When coal was king, the population was much higher in the Wyoming and Lackawanna Valleys. There were a lot more people, freight and of course anthracite coal traffic to be moved.

There is a lot of road, rail, and canal infrastructure left over from King Coal. Some canal locks in West Nanticoke, Lehigh Gorge State Park near White Haven and Jim Thorpe are examples. If you walk the DL trail from Jim Thorpe to Wiessport and Bownanstown, you can see several locks and a few lock tenders' shacks.

Bridges from Marvine Colliery

In the fall of 2021, a new trail opened in North Scranton, off of Parker Street. The trail goes though mine scarred lands of the former Marvine Colliery Complex.

Two bridges span a railroad track and the Lackawanna River. These are two bridges left over from the Marvine Colliery. The one carried a conveyor line to the head house of the Marvine shaft. The other bridge carried mine cars.

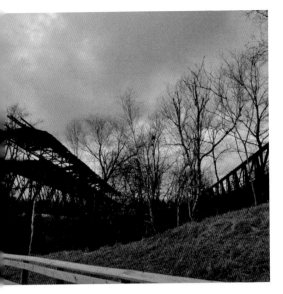
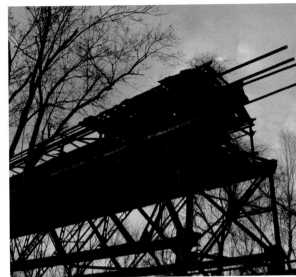

Marvine conveyors and bridge from rail to trail.

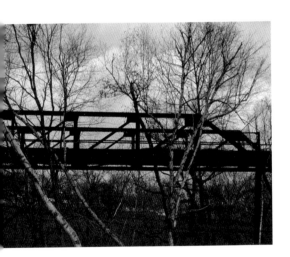
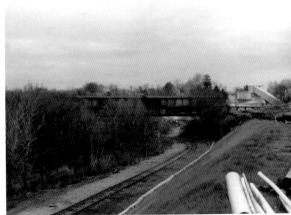

Above left: Marvine conveyors and bridge from rail to trail.

Above right: A late 1990s side view of bridges.

Canal Place Names Live On

The idea of using boats on a canal predates railroads in Northeastern PA. Except for a few segments of canal to the south of us, canals have been forgotten. Just memories of a bygone era, but are they?

In Luzerne County, Port Bowkley, Port Blanchard. and Port Griffith were all place names that came from locations on the North Branch Canal. How many more of these old canal place names can you find?

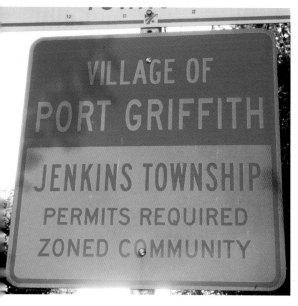 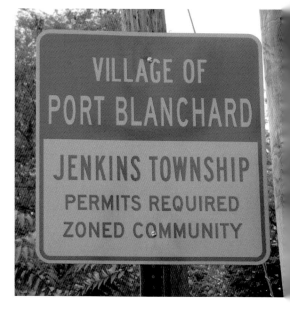

Above left: Port Griffith sign.

Above right: Port Blanchard sign.

Canal Lock, Lock Tender's House, Walnutport PA

In Walnutport, PA, there is a canal lock and a nicely restored lock tender's house. The DL trail runs through this little park. The house is made of stone.

This is from the former Lehigh Canal. This transportation system predates railroads. Mules or horses pulled a boat of coal or other cargo along a towpath. The boat moved along the canal basin. Locks raised and lowered boats as the elevation of the canal changed.

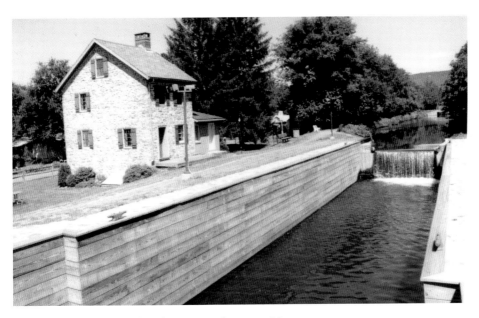

Canal lock and lock tender's house in Walnutport, PA.

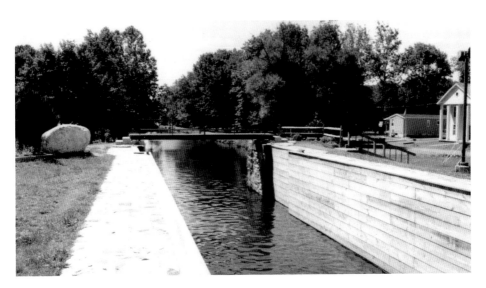

Canal Locks, West Nanticoke

Located near the back of Canal Park in West Naticoke, there are the remains of some canal locks. The park and a playground and some space for recreation.

The remains of the locks consist of stone blocks. Areas of the canal around it are grow in with trees and filled in. These photos were taken in the late 1990s. Anthracite was the major cargo for the canal.

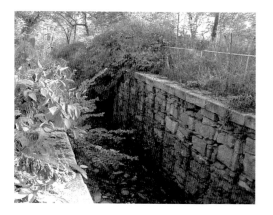 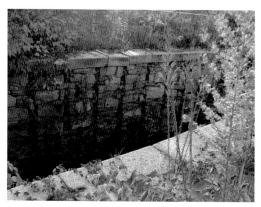

West Nanticoke canal locks.

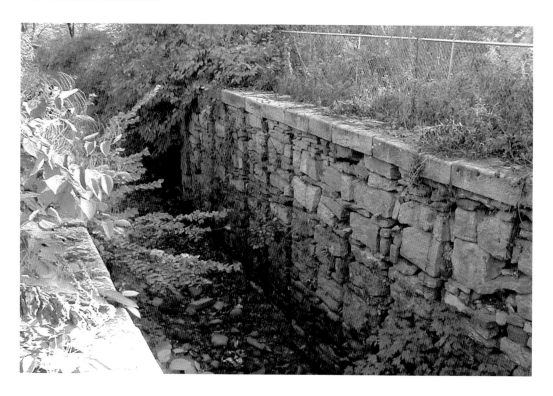

Canal Channel in Wilkes-Barre?

While this cannot be verified 100%, this looks like the channel of the North Branch Canal in Wilkes-Barre. These photos are from the early 1990s.

This was behind the Hollenback Cemetery and the Dorrance Colliery area in the north end of Wilkes-Barre. The stone wall could have been part of a lock.

A short distance away, in the vicinity of the former Laurel Line trestle over Mill Creek, the canal had an aqueduct here, to carry the boats over the creek, but that was in the era before railroads.

A possible canal channel.

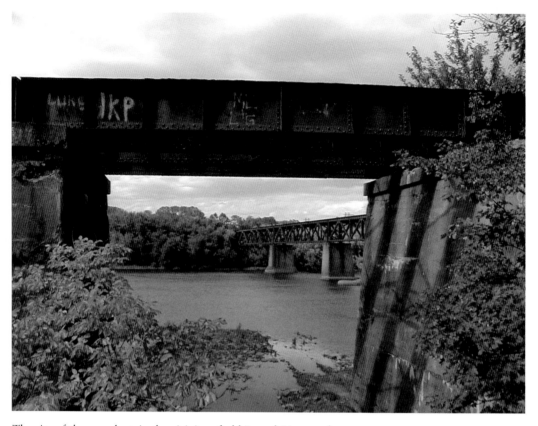

The site of the aqueduct, in the vicinity of old Laurel Line trestle.

Stone Arch at Carey's Patch, Ashley, PA

Situated beyond the site of the former Huber Breaker is the neighborhood of Carey's Patch. To get into Carey's patch, you must go under a stone arch that carried a now abandoned railroad line back around toward the CNJ Railyard.

Recently, the Luzerne County Redevelopment Authority wants to demolish the stone arch but residents want to keep it to retain the character of the neighborhood.

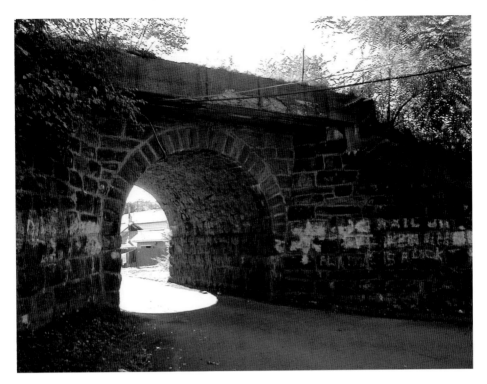

A stone arch in Carey's Patch.

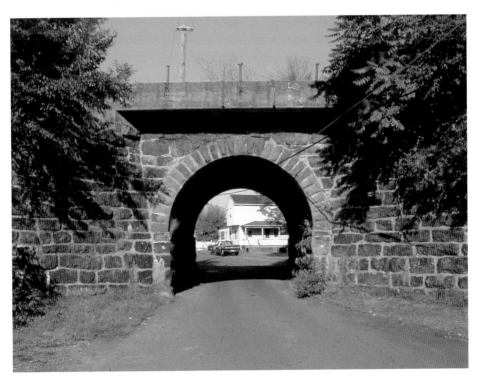

Coaldale Bus Shelter

Along Route 209 in Coaldale, there is a bus shelter that was used by the coal miners to reach a nearby mine. The bus shelter had been recently restored. It is emblazoned with motivational slogans: "Everybody's Goal—Mine more Coal" and "A Car More A Day Means More Pay". It is interesting to see this part of history preserved.

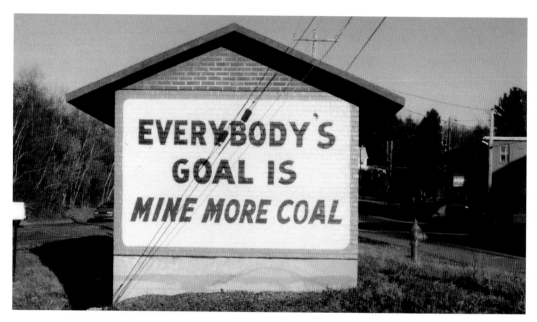

Coaldale bus shelter.

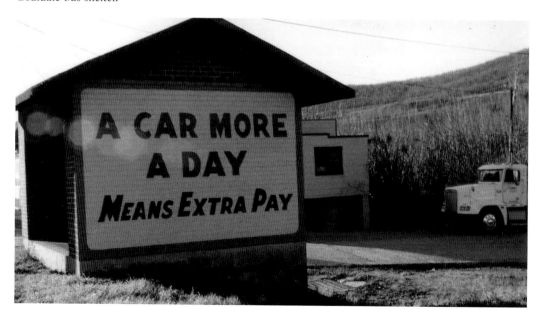

Jeddo Switcher at Community Park

Recently, one of the switchers from the Jeddo Highland Coal Company was put on display at the Hazle Twp. Community Park. This switcher worked at the Jeddo Highland Coal Breaker in Jeddo, PA, just outside of Hazleton. The little locomotive is a GE 25-ton switcher. This model was commonly used in industry, mines, and quarries.

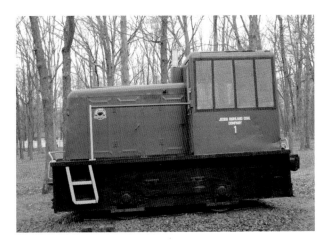

Former Jeddo Switcher on display.

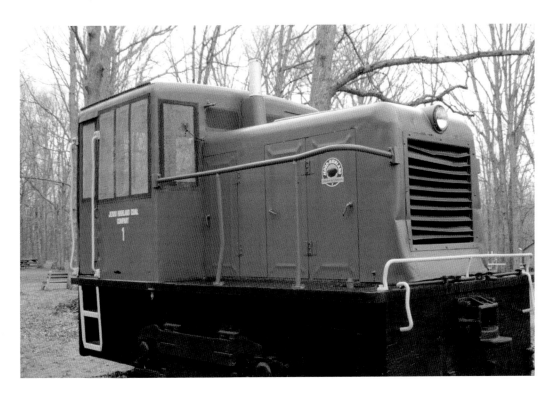

West Nanticoke Branch Trestle

A railroad trestle crosses the river at West Nanticoke. It was part of the Pennsyvainia Railroad's West Nanticoke Branch. Some approaches still stand in the swampy area on the Nanticoke side.

This was part of the web of trackage that criss-crossed the Wyoming Valley to take anthracite coal and other goods to market. The branch crossed the river and ran parallel to the DL&W Railroad's Bloomsburg line and ended in a yard.

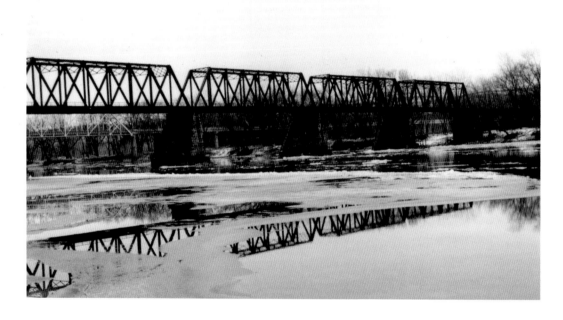

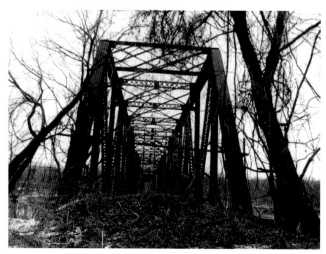

West Nanticoke trestle.

D&H Plymouth Branch Trestle

These photos show the demolition of the old D&H Plymouth branch trestle. This bridge was demolished as a flood protection measure and to keep people from climbing on it.

This trestle carried tracks from the D&H railroad across the Susquehanna River. The branch ran from the present-day Barney Farms to connect with the DL&W Railroad's Bloomsburg line. Further down the line, a branch diverged and crossed Route 11 to service the D&H Lorree Colliery operation in Larksville.

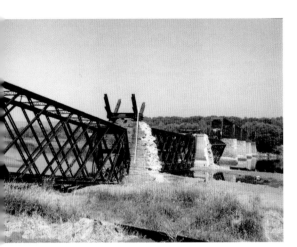
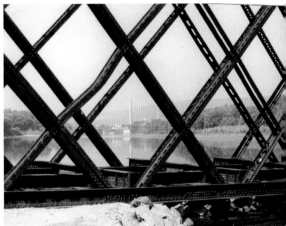

Above and below left: The demolition of the D&H Plymouth branch trestle.

Below right: Branch to Lorree Colliery crossing Route 11 in Larksville.

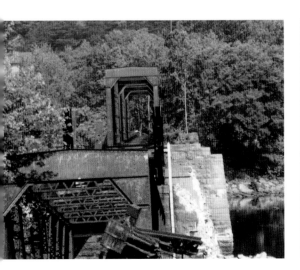

Riverwalk Trail, Carbondale PA

The author found this by accident. Walking back from nearby Gravity Park in Carbondale, some bright lettering drew attention to this little park and playground. It was the trail head for the Riverwalk trail, that naturally, runs along the Lackawanna River.

On a stone bridge abutment from the O&W Railroad, a mural of a miner and steam locomotive is painted on it. Low rise senior housing is located at the start of the trail. Many of the residents were walking on the trail and sitting on benches.

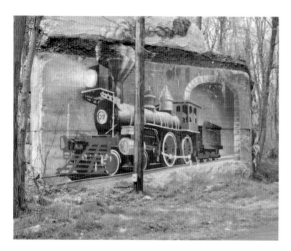

Above left: Mural on O&W abutment.

Above right: Signage.

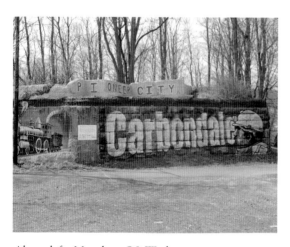

Above left: Mural on O&W abutment.

Above right: Riverwalk trail.

Kingston Roundhouse

There was once a railroad yard at Kingston, PA, on the DL&W Railroad's Bloomsburg line. It was a good sized yard. The purpose of the yard was to handle the oubound coal traffic from nearby mines, as well as other freight.

The roundhouse stood for many years. In the 1970s, the roundhouse was used as a beer distributor. Old freight trailers and other vehicles were stored on the property, prior to its demolition.

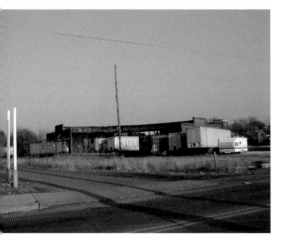
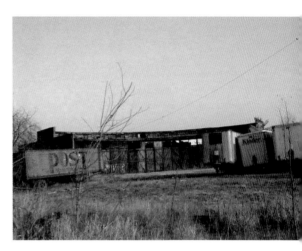

Kingston roundhouse.

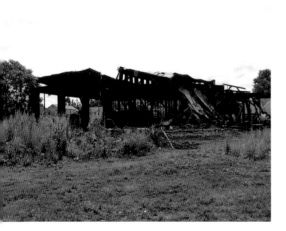
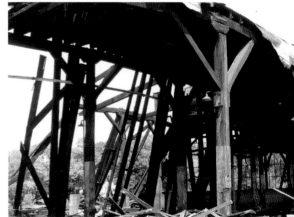

*Above left:*Demolition of roundhouse.

Above right: Beams from old roundhouse.

Odds and Ends

In closing, here are some interesting photos. There are still a lot of traces and mementos of the anthracite industry in Northeastern Pennsylvania.

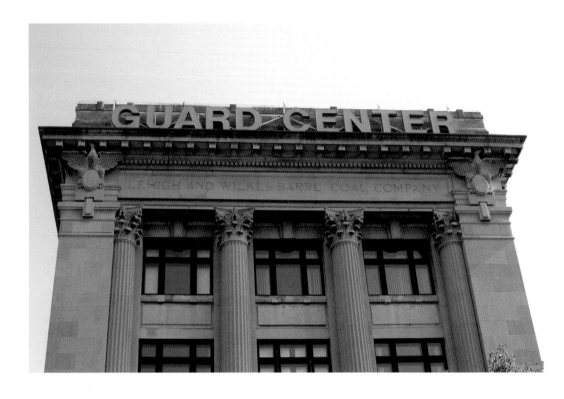

Above: Former Lehigh and Wilkes-Barre Coal Company building.

Left: Coal miners kneel in prayer at the door of St Mary's Protection Byzantine Rite Church in Kingston, PA.

Above: A chunk of coal on the side of Oak Street in Taylor, PA.

Below left: Blue Coal sign in the Anthracite Museum in McDade Park, Scranton, PA.

Below right: Mine subsidence on Dillon Street in the Miners Mill section of Wilkes-Barre, PA.

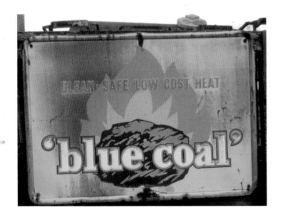

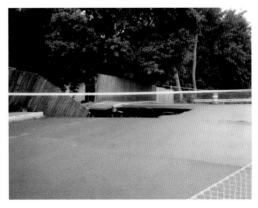

About the Author

Michael G. Rushton graduated from Bishop Hoban High School and became interested in industrial archeology. After high school, he attended King's College, where he studied computer information systems. He dabbled in photography, eventually buying a Pentax K-1000. He considers himself an amateur photographer and industrial archaeologist.